COLOR PRIMER I & II

Richard D. Zakia and Hollis N. Todd

MORGAN & MORGAN, INC. Publishers
Dobbs Ferry, New York
The Fountain Press, London

© Richard D. Zakia and Hollis N. Todd 1974

All rights reserved in all countries. No part of this book may be reproduced or translated in any form, including microfiling, without permission in writing from the authors and publishers.

Morgan & Morgan, Inc., Publishers 145 Palisade Street Dobbs Ferry, New York 10522

International Standard Book Number 0-87100-021-0 Library of Congress Catalog Card Number 74-83103

Typeset by Morgan Press Incorporated Printed in U.S.A.

Third Printing 1978

THIS BOOK IS DIFFERENT

This is not a conventional type of book. It is a book of programmed instruction which has been carefully designed to assist you in learning some of the basic concepts of color by yourself, at your own learning rate and at your convenience. This program, then, is designed especially for you.

Keep these things in mind as you work through this book. You will notice that the format consists of a series of questions you are to answer in writing. Immediately following is an answer to each question. It is important to answer each question in its proper turn. Avoid skipping forward. The sequence of questions and answers has been carefully designed to facilitate your learning. Meaningful repetition and redundancy are important to learning and have, therefore, been built into this program on color. You will also find that the questions are relatively simple at first and then become more complex.

To get the most from this book, follow these simple directions:

- Read each item carefully and when you feel you understand it, write in the answer.
- 2. Turn the page to check your answer and then go to the next question.

Start with Color Primer I and work through to the end. Then turn the book around and continue through Color Primer II.

RIT Student Sculpture

Photo by: John J. Dowdell, III

Yellow pigment 1, 2, 6, 7, 14, 21-24 combined with cyan pigment 25, 26, 28, 32 combined with magenta pigment 40-45

12,64 ətidW

INTRODUCTION

All of us are in some way involved in color. We are very strongly influenced by color and many of the things we select to buy are based on our color preferences. You need know very little about color to enjoy it, but to be actively involved in producing colors or teaching about colors, you must have some knowledge of color principles. This is true whether you are working in or studying for such diverse areas as photography, art, television, graphic arts, chemistry, decorating, theatre, etc.

This book is conveniently divided into two sections. The first section, **Color Primer I**, deals with the colors that are produced when colored **lights** are mixed. The second section, **Color Primer II**, deals with the colors that are produced when colored **pigments** are mixed. Throughout this book you will be given bits of information followed by a pertinent question to be answered and then, on the next page, the immediate answer to the question. To assist you in the learning,

42, 48, 49 45, 48, 49

Strong filters See 9aturated
Subtractive color formation Introduction, Summary
Three pigments combined 46-48, 53-56
Unsaturated colors 54-56

Saturated pigments 3, 4, 11, 12, 17, 19, 23, 24, 36, 45, 53

Nue, from magenta and yellow pigments 40-45 light, absorbed by cyan pigment 16-21, 23, 24, 26, 35 not absorbed by magenta pigment 8, 9, 14, 22 not absorbed by yellow pigment 2, 7, 14, 22

Primaries (subtractive) Summary

we have designed some simple demonstrations that allow you to mix colors and witness the effect of such mixtures. In **Color Primer II**, you will be mixing pigments using a set of three filters.

To see the effects of mixing colored lights as described in Color Primer I, one method requires three slide projectors, each having a red or green or blue filter in the slide position, projected so that the colored lights overlap. A much simpler method uses a tube and diffusers to see the mixed light transmitted through three adjacent filters—red, green and blue—as in the photograph to the right.

Pigments Introduction 1, 4, 6, 9, 14, 17, 18, 22, 23, 27, 28, 31, 32, 35, 44, 47, 50, 51, 54-56

Pale dyes (filters) 3, 5, 11, 13, 18, 20, 23, 24, 31, 37, 42, 45, 48, 49

Pairs of pigments combined blue with yellow 27, 30 cyan with magenta 34-36, 28, 29, 31-33, 45 cyan with yellow 25, 26, 28, 29, 31-33, 45 magenta with yellow 41-45

Orange hue (from yellow and magenta pigments) 43, 56 Paints 7, 13, 20, 29, 30, Summary

Neutral colors Introduction, 46-51 from yellow and blue pigments 27, 30

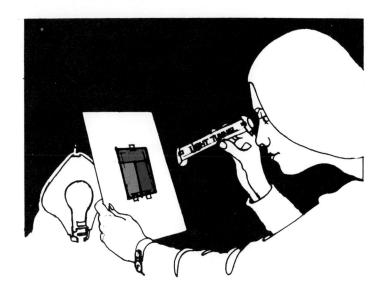

A light diffusing tube is used to view color mixtures of light.

Magenta pigment 8-10, 14, 22-24 combined with cyan pigment 34-39, 45 combined with yellow pigment 40-45

not absorbed by yellow pigment 15, 22 not absorbed by yellow pigment 2, 7, 14, 22

31-33, 45 light, absorbed by magenta pigment 10-14, 21, 23, 24, 35, 41

Green hue, from cyan and yellow pigments 25, 26, 28,

Gray 48, 52

Filters 1-3, 8, 10, 12, 15, 16, 19, 24, 26, 35, 40, 46

Dyes Introduction, 1, 4, 5, 11, 21, 25, 33-39, 41-43, 45, 48-50, 53, Summary

INDEX

INSTRUCTIONS FOR BUILDING AND USING THE TUBE DIFFUSER

- 1. Roll a sheet of white 8 x 11 paper to form a tube about ½" in diameter. Use tape to fasten.
- Cut two pieces of waxed paper about 1 x 2", and fold so as to make two squares of two layers each. Tape one square on each end of the tube.
- Select the red, green, and blue filters from the filter kit and join them together with bits of tape to make an arrangement like the one below.

4. Hold the filters in front of a frosted light bulb. Look through the tube at the filters, with one end of

Dull colors 54-56

Cyan pigment 15, 16, 19, 22-24 Combined with magenta pigment 34-39, 45 combined with yellow pigment 25, 26, 28, 32, 45

Brown 56

not absorbed by cyan pigment 15, 22 not absorbed by magenta pigment 8, 9, 14, 22

76, 41

Blue, from magenta and cyan pigments 34-39, 45, 55 light, absorbed by yellow pigment 1, 3-7, 14, 21, 23,

Black 46-48, 51 from yellow and blue pigments 27

(Numbers refer to questions)

the tube close to the filters. By moving the tube about, you can see a mixture of light that has come through one of the filters, or partially through two of them in any pair, or partially through all three of them.

Notes: A 25-watt lamp is sufficiently bright if you work in a dimly lighted room. Depending on the waxed paper, you may need to use more than two layers to mix the light well by diffusion. You may need to shield the upper part of the tube from stray light.

We believe you will enjoy going through this book and that you will effectively learn about the basic principles of color mixing. This belief is based on the firm pedagogical conviction that seeing assists believing, and that doing assists learning.

> Richard D. Zakia Hollis N. Todd

 To make almost any color, we need to use different amounts of just the basic pigments CYAN, MAGENTA, and YELLOW.

b) The neutral color gray can be made by combining MEDIUM amounts of the three basic pigments.

9. a) Combining large amounts of all three basic pigments makes the neutral color BLACK.

SHEWSHA YRAMMUS

THINGS YOU WILL LEARN

Primer I is designed to help you learn these 12 things:

- 1. The names of nine important colors;
- 2. What colors are called neutral;
- 3. The three attributes or characteristics of color;
- 4. The difference between the terms brightness and lightness;
- 5. Two important sources of white light;
- White light can be produced by mixing only three different colors of light;

In order to make almost any color, we need to use different amounts of just the basic pigments	10.
b) The neutral color GRAY can be made by combining (small, medium, large) the three basic pigments.	
a) Combining LARGE amounts of all three basic pigments makes the neutral color	.6

SUMMARY QUESTION

SUMMARY ANSWER

of CYAN pigment. amount of yellow pigment with a SMALL amount 8. a) Yellowish-green can be made by mixing a LAHGE

of MAGENTA pigment. ot yellow pigment with a SMALL amount of b) Orange can be made by mixing a LARGE amount

- 12. Black and white are colors.
- neutrals are formed:
- 11. In an additive system, how colors other than
- additive system of producing colors;
- 9. How the three additive primaries can be mixed to produce neutrals; 10. A very important color system which is based on an
- 8. What colors are produced by adding only two of the additive primaries;
- 7. The three primary colors for additive color mixtures:

SUMMARY QUESTIONS

(large, small)	.friempig	amount of
	v pigment with a –	amount of yellov
(large, small)	ange can be made by mixing a	
	.tnemgiq	amount of
(large, small)	n pigment with a –	amount of yellov
nixing a(large, small)	сви ре швде ру п	8. a) Yellowish-green

ADDITIVE SYSTEM OF COLOR

Red, Green and Blue Light Phosphors

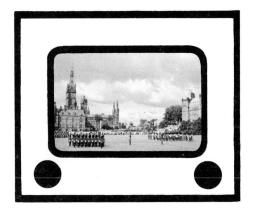

SUMMARY ANSWERS

Identify the colors below as either GREEN, BLUE, RED, BLACK, WHITE or GRAY.

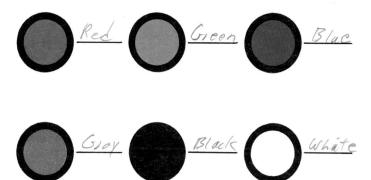

After you write in your answers, check them on the back of this page.

7. With small amounts of the basic pigments we can

6. With large amounts of the basic pigments we can

QUESTION 1

make WEAK colors.

make STRONG colors.

The colors RED, GREEN, BLUE, GRAY, BLACK and WHITE are correctly identified below.

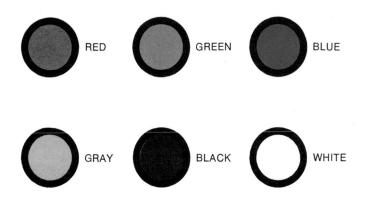

Learn them if you need to, and then go to the next question.

6. With LARGE amounts of the basic pigments, we can aske _____ colors.
7. With SMALL amounts of the basic pigments, we can make _____ colors.

SUMMARY QUESTION

SUMMARY ANSWER

5. a) Hues of red can be made by combining MAGENTA and YELLOW pigments (either order).

b) Hues of blue can be made by combining CYAN and MAGENTA pigments (either order).

c) Hues of green can be made by combining CYAN and YELLOW pigments (either order).

2. White

1. Black

Of the six colors listed in the previous question, three are NEUTRAL colors. List the three neutral colors:

WHITE, GRAY and BLACK are neutral colors.

Neutral colors are those which do not look reddish, greenish, bluish, yellowish, etc.

The white paper of this book and the black ink are neutral.

(Go to the next question.)	

pigments.	guq —	
GREEN can be made by combining		
pigments.	guq —	
BLUE can be made by combining	to səuH (d	
pigments.	guq —	
HED can be made by combining ———	a) Hues of	.c

SUMMARY QUESTION

When we talk about a color being red, green, blue, etc., we are telling about that aspect of color that is called HUE. Use the technical word HUE, then, to refer to that property of color we call redness, greenness, etc.

Neutrals are colors that have no hue. This is why they are called neutrals.

b) Weak (pale) pigments absorb LITTLE light.

4. a) Strong (saturated) pigments absorb MUCH light.

SUMMARY ANSWER

answer 3

Grass in the summertime would have a green HUE. In the wintertime or during a severe summer dry spell, the green hue might shift to a yellow hue.

(elttie)	(шпсµ
.tdgil	b) Weak (pale) pigments absorb
(much, little)	light.
	4. a) Strong (saturated) pigments absorb

SUMMARY QUESTION

SHAWERS ANSWERS

1. The three basic pigments are (any order): a) YELLOW b) MAGENTA c) CYAN

2. The color of light that is absorbed by each pigment is

g) BFNE p) GBEEN c) BED (same order as 1):

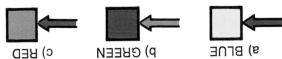

The colors of light that are NOT absorbed by each pigment are (same order as 1):

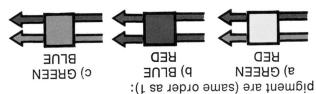

White milk has a <u>neateal</u> color of no hue.

ANSWER 4

White milk has a NEUTRAL color of no hue. If you use milk to make a strawberry milkshake, it would then have a pinkish hue and would no longer have a neutral color with no hue.

color with no hue.	
g)	
In the same order, name the two colors of light that are NOT absorbed by each of the same pigments:	3.
a) ————————————————————————————————————	
In the same order, name the color of light that is absorbed by each of the same pigments:	2.
g)	
Name the three basic pigments:	٦.
SUMMARY QUESTIONS	
SINDITSHID VOAMMIIS	

QUESTION 5

COLOR PRIMER II. Proceed.

and yellow.

You are now ready for your last set of questions for

about are often called the "subtractive" primaries. For these reasons, the three dyes you have learned

paint. These must be cyan, magenta and yellow. imitate all natural colors by using only three tubes of If a painter chooses his paints well, he can tairly-well

different amounts of just three inks-cyan, magenta In magazines, "three-color" printing processes contain

YAAMMUS (b'Inoo)

Which set of the items below would you consider to be NEUTRAL in color?

- 1. Grass, Charcoal and Tomatoes
- 2. Charcoal, Tomatoes and Milk
- 3. Charcoal, Milk and Tar

If your answer was (3) Charcoal, Milk and Tar, excellent! You have identified Charcoal, Milk and Tar as having NEUTRAL colors. We call them neutral colors because they are black, gray or white, and are unlike reds, blues, greens and yellows.

If your answer was (1) Grass, Charcoal and Tomatoes, you are partially correct. Charcoal has a NEUTRAL color. Grass is green and tomatoes are red; these are not neutral colors. Colors like black, gray and white and variations of gray, such as dark gray, etc., are all NEUTRAL colors.

If your answer was (2) Charcoal, Tomatoes and Milk, you are partially correct. Charcoal and milk have NEUTRAL colors. Tomatoes, which are red, do not. Colors like black, gray and white, and variations of gray, such as dark gray, etc., are all NEUTRAL colors.

A color photograph consists of different amounts of cyan, magenta and yellow dyes. By controlling the amounts of the dyes, almost any color can be imitated.

We can make colors in between strong colors and neutrals by using the three pigments in unequal amounts.

We can make neutrals by using the three pigments together, in about equal amounts.

We can make atrong or weak colors of any hue by using more or less of the pigments in pairs.

We can make almost any color appearance whatever by properly mixing just three pigments. The pigments are yellow, magenta and cyan.

YAAMMUS

It is helpful, in thinking about color, to image a baseball diamond. Neutral colors are homebase. Nonneutral colors like red, green, and blue are at first, second, and third base. If we do this we can look upon a hue as describing its **direction** relative to neutral (homebase).

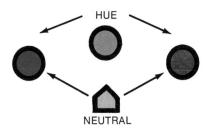

The hue of a color tells its ______ relative to a neutral color.

We can make orange by adding a large amount of YELLOW pigment to a lesser amount of MAGENTA pigment. We can make a dull orange, that is, a brown, by adding a little CYAN pigment.

OC ASWER

The DIRECTION of a color away from neutral is described by its hue.

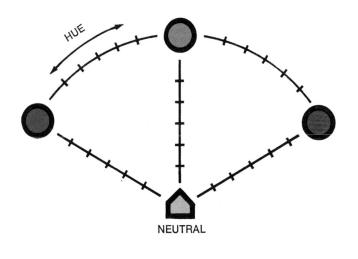

Brown is a dark, dull orange color. We can make orange by using a large amount of ______ pigment and a somewhat lesser amount of _____ pigment. We make the orange dull (less saturated) and thus **brown**, by adding a small amount of the third pigment, that is _____.

OUESTION 56

Although hue describes the **direction** of a particular color relative to neutral, it does not tell how far away from neutral the color is. Take red apples as an example. They all have the same red hue but some will be more reddish than others. They will occupy a different **position** along the red hue direction. The position they occupy is technically called SATURATION.* The more reddish an apple is, the more saturated it is.

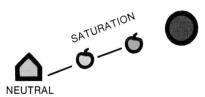

A pale blue sky is less <u>Saturated</u> than a deep blue sky.

*In the Munsell system of color notation, the word CHROMA is used to refer to saturation.

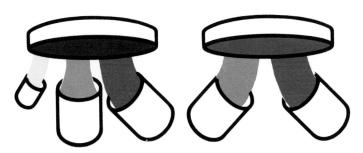

We make blue by adding MAGENTA pigment to CYAN pigment. We make the blue color dull (less saturated) adding some YELLOW pigment.

В вызмен

A pale blue sky is less SATURATED than a deep blue sky. Although the hue is the same (blue), the saturation differs.

By the same reasoning, navy blue is a **dull** blue. We know that we can make a blue color by adding to ——(pigments). We can make the blue color to——ull by adding some of the third pigment, that is

PG REWER

A yellow banana and a lemon have the same <u>hue</u> but could differ in <u>saturation</u>

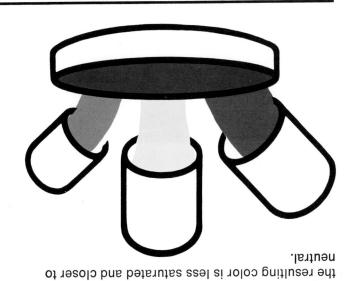

We can make a strong red dull by adding to the magenta and yellow some of the third pigment, CYAN;

QUESTION 8

Yellow bananas and lemons have the same yellow HUE but they could differ in SATURATION.

Although they have the same hue (direction) relative to neutral, they may occupy different positions (saturation) on the scale.

Maroon is also red, and could be made by mixing magenta and yellow pigments. But maroon is a **dull** red and, therefore, nearer neutral gray than is fire-engine red. We could make the strong red nearer neutral (less saturated) by adding some of the third pigment, which is

Relative to a neutral position, hue describes the ______ of a color and saturation describes the position of that color.

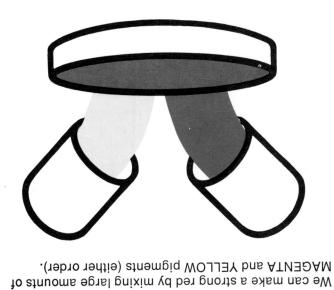

ANSWER

QUESTION 9

Hue describes DIRECTION relative to a neutral position while saturation describes POSITION.

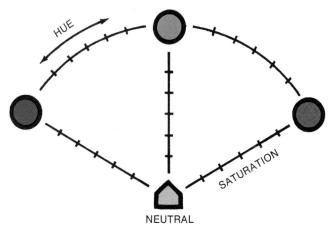

(Later, we will introduce another property of color, called BRIGHTNESS or LIGHTNESS.)

and pigments.
could produce that color by mixing large amounts of
For example, fire engines are painted a strong red. We
(saturated) hues and neutrals.
amounts, we can make colors between strong
make neutrals. If we use the three dyes, but in unequal
using the three dyes together in equal amounts, we can
By using the dyes in pairs, we can make any hue. By
By using just three dyes we can make almost any color.

QUESTION 53

At this point in the program, we have learned three technical names (NEUTRALS, HUE and SATURATION) and we have named six colors (red, green, blue, white, gray and black).

Look at these eight colors listed and use the numbers to name those colors which:

- a) are neutrals. 2,5,8
- b) have the same hue and saturation. 1, 7
- c) have the same hue but different saturation. 4, 6

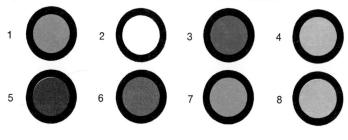

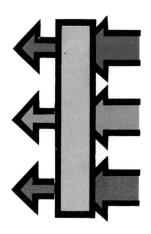

Neutral (gray) sunglasses absorb a MEDIUM (or MODERATE) amount of all the colors present in white light.

25

ANSWER

ANSWER 10

a) Neutrals 2, 5, 8

b) Same hue and saturation 1,7

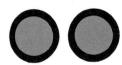

c) Same hue but different saturation 6, 4

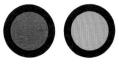

Some sunglasses are neutral gray. They absorb a amount of all the colors present in white light.

We have reviewed the terms, neutral, hue and saturation, and the six basic colors, red, green, blue, black, gray and white. We need now to add three more basic colors to our list.

The first one has a yellow hue and you are familiar with it.

0

The second one has a hue that is familiar but perhaps the name is not.

What name do you call it?

A white pigment (or white paper) absorbs practically NO light; a black pigment absorbs practically ALL light.

ANSWER

ANSWER 11

The correct technical name for it is CYAN, pronounced "sigh-ann." You might have thought that this color had a blue hue. It is not blue but rather a **bluish-green**. Compare the hue of CYAN to the hue of the color blue.

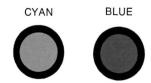

Cyan is a color intermediate between blue and green.

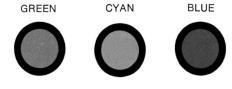

The lightness of a neutral color is determined by how much light it absorbs. A white pigment absorbs practically _____ light. A black pigment absorbs practically _____ light.

Another basic color has a hue that is probably familiar to you, but what is the correct technical name?

Black, gray, and white are neutral colors, without hue or saturation, differing only in lightness.

When equal quantities of the three dyes are mixed, large quantities produce a BLACK color; moderate amounts produce a GRAY color; very small amounts produce a nearly WHITE color.

UC ABWENA

The correct name is MAGENTA. It has a hue intermediate between red and blue. It is a **bluish-red** or a **reddish-blue**.

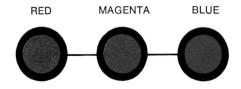

Thus we can make neutral colors by mixing equal amounts of yellow, magenta, and cyan pigments. If the tresulting color is _____; if they are mixed in moderate equal amounts, the resulting color is _____; if they are mixed in very small amounts, the resulting color is _____;

09 "

QUESTION

QUESTION 13

Now, let's see you properly identify these three basic colors by their hues.

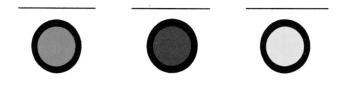

Equal, very very small amounts of the three dyes would absorb almost no light, and the resulting color would be almost WHITE. White is a very light gray; it has high lightness.

94 ABWENA

CYAN

MAGENTA

YELLOW

0

O

Well done, if you got them all correct. If you missed identifying any, pause and learn them.

Equal, very **very** small amounts of the three dyes would together absorb almost no light, and the resulting color would be almost ...

QUESTION 14

Before we continue with our Color Primer, it is essential to prove to ourselves that we know the correct names of the nine colors presented in this unit.

Name the colors below.

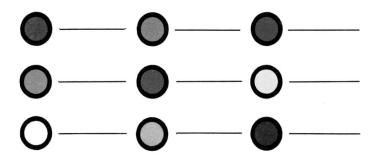

Grays are like black in that they are neutral. Grays are lighter neutrals than black.

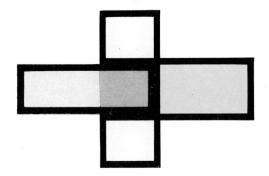

Equal, small amounts of the three dyes (yellow, magenta and cyan) would produce a LIGHT (or PALE) gray. Moderate amounts of the three dyes in equal quatity would produce a medium gray.

ANSWER 48

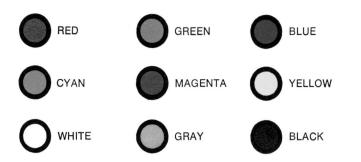

If you have them all correct, you are doing well. If you missed naming one or more of the basic colors properly, please pause and learn their names.

(Please note that three of the colors above are neutrals and therefore have no hues. The other six are colors having red, green, blue, cyan, magenta and yellow hues.)

----- дгау.

In the kit, you are using large, nearly equal amounts of the three dyes; together, they make a very dark gray, practically black. If you were to mix much smaller, equal amounts of the three dyes, they would make a Which of the nine colors that you have learned would you list as neutrals?

Write them in this block:

And the same of th		HEROTONIA DO LA VIGINIA
1		
1		
1		
1		
ı		
1		
I		
1		
		and the second second

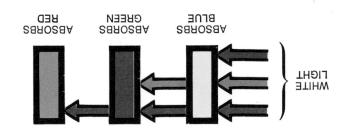

When we mix yellow, magenta, and cyan pigments together, they absorb practically ALL the light, giving a very dark, nearly neutral, and practically black color.

TA ABWENA

The colors | black, gray and white | are called neutrals.

If you feel a need to review neutrals, please return to questions 4, 5 and 10.

and together they absorb practically _____ the light. pigments absorbs one of the three parts of white light, magenta, and cyan pigments, because each of the It is reasonable to get nearly black when we mix yellow,

Now, let's scramble the nine colors we have studied and then correctly name them.

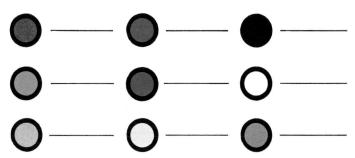

When we mix all three dyes together, the result is a very dark neutral, practically BLACK.

ANSWER

Did you name them all correctly?

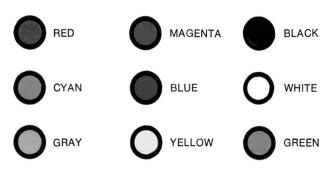

If you got all of them correct, excellent! Correct identification of these nine colors is essential for further progress in learning about color.

You have learned that any color hue can be made from just three pigments by mixing them in different pairs. Now put all three (yellow, magenta and cyan) filters together on top of each other. You see that the resulting color is a very dark neutral, practically

In order to see such colors as RED, GREEN, BLUE, CYAN, MAGENTA, YELLOW, WHITE, GRAY and BLACK, you need to have a source of LIGHT. An important source of indoor light is a TUNGSTEN bulb. We refer to the color of light given off from a tungsten bulb as WHITE LIGHT. When you turn on a tungsten lamp, the room is filled with ___________.

18	∃J∀d	GBEEN	weak cyan Weak yellow and
01⁄2	DEEP	BED	Strong yellow and strong magenta
25	PALE	BLUE	Meak magenta and
34	DEEP	BLUE	Strong cyan and strong magenta
42	BJA9	BED	Weak yellow and weak magenta
52	DEEP	GBEEN	Strong yellow and strong cyan
SEE ANSWER AJBER	COLOR OR PALE DEEP	HOE COLOR HUE	MIXED PIGMENTS

PASWER 45

WHITE LIGHT is given off by a tungsten lamp. Based on your experience, you may question this. You recognize that if you turn on a tungsten lamp during the day, it tends to look yellowish. This is because you are influenced by the daylight outdoors. At night, when it is dark outdoors, the tungsten lamp indoors will look white.

Meak yellow and weak cyan		
Strong yellow and strong magenta		
Меак тадепта апд меак суап		
Strong cyan and strong magenta		
Weak yellow and weak magenta		
Strong yellow and strong cyan	·	
PIGMENTS MIXED	HUE	СОГОВ
reloios and in dean	RESULTING COLOR	OB PALE DEEP

You have now seen that three dyes, used alone or in pairs, can produce very many different colors and, in fact, all the different hues. To check your understanding to this point, fill in the summary table below. It involves making the basic colors red, green and blue, and either

QLESTION 45

There are other indoor sources of white light, such as fluorescent, but for this unit we are interested only in tungsten. A very important source of white light outdoors is the ______.

These red colors would differ in hue, lightness or saturation, or in any combination of these.

colors.

When we mix different amounts of magenta and yellow pigments, we can make many different kinds of RED

The SUN is our primary source of outdoor light. You might have written "moon." Your answer would be acceptable, but we are interested in the white light the sun gives off during the daylight hours, not the white sunlight reflected from the moon.

colors.

Thus, by mixing different amounts of magenta and yellow pigments, we can make many different kinds of

If we consider the sun as a source of light, we can say it gives off white light. So does your color television set. The picture tube consists of red, green and blue light phosphors which mix to produce ______.

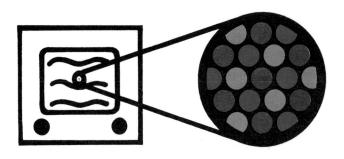

Enlarged view of a color TV screen.

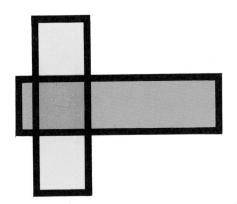

By mixing a lot of yellow pigment with a little magenta pigment, we would make a YELLOWISH-red color, or orange.

EA ABWENA

Red, green and blue light phosphors mix to produce white light and other neutral colors as well as non-neutral colors such as reds, greens, blues, etc. You can see this by simply holding a magnifying glass or the removable lens of your camera up to a TV screen. (Caution—Do not place your eye close to the TV screen.)

For this unit of study we will restrict ourselves to a tungsten lamp and the sun as two very important sources of white light.

The principles of color we will learn, however, are applicable to how colors are produced on television or any other system of ADDITIVE COLOR MIXTURE.

If we were to mix a lot of magenta dye with only a little yellow dye, we would make a purplish-red color. If we were to mix a lot of yellow dye with only a little magenta dye, we would make a ______ ish-red color, usually called orange.

Have you ever seen the sun shining outdoors while it was raining? If you have, you might have observed a rainbow of colors. In this rainbow are colors such as red, yellow, green, blue and violet. RED, GREEN and BLUE are of principal interest to us. You may remember from science class that a rainbow of colors is formed when white light from the sun or a tungsten lamp, in passing through a prism, is separated into a variety of colors. (Raindrops act as prisms.)

When Sir Isaac Newton allowed sunlight to pass
through a prism, he identified the spectrum of color as
containing seven hues: red, orange, yellow, green,
blue, indigo and violet. Actually, there are nearly 100
visibly different hues in the spectrum. The hues of the
three colors that are of principal interest to us are
and

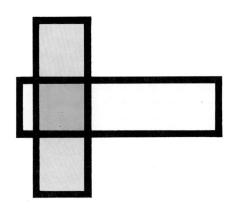

A pale red (pink) color would be made from only SMALL amounts of magenta and yellow pigments.

ANSWER 42

Of principal interest are the hues RED, GREEN and BLUE.

The amounts of the mixed magenta and yellow dyes will determine the exact color of red that will be made.

A pale red (a pink) would be made from only amounts of magenta and yellow.

Red, green and blue light a	re of principal interest	
because they can be added	d or mixed to form white	Э
light. White light can be pro	oduced by the proper	
mixture of	and	light.

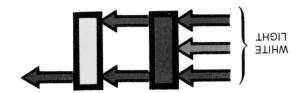

Because the magenta pigment absorbs GREEN light and the yellow pigment absorbs BLUE light, of the original white light, only RED is left for us to see.

White light can be produced by the proper mixture of RED, GREEN and BLUE light. Prove this to yourself by using your light tunnel and red, green and blue filters.

	for us to see.
thgil	leaving, from white light, only the
,thgil	light and the yellow pigment absorbs
	because the magenta pigment absorbs
oduce red	When mixed, magenta and yellow dyes pr

Lt

QUESTION

Because red, green and blue light can be added to form white light, they are referred to as the PRIMARY COLORS for additive color mixtures. In the additive color system, red, green and blue are called ______ colors.

Mhen mixed, magenta and yellow pigments produce

ANSWER 40

In the additive color system, red, green and blue are called PRIMARY colors.

Now place the magenta and yellow filters together on top of each other. You see a _____ color.

QUESTION 23

By mixing the three _____ colors of the additive system, we can produce white light.

These blue colors differ in hue, or saturation, or lightness, or any combination of these.

By using different amounts of magenta and cyan pigments, we can produce many different kinds of pLUE colors.

S ASWER

By mixing the PRIMARY colors of the additive system, we can produce white light.

Additive Primaries: red, green and blue

Thus, by using different amounts of magenta and cyan dyes, we can produce strong or weak, reddish or greenish

Since red, green and blue light primaries can be added	
to form white light, we can think of white light as being	
made up of, and	_
light.	

38

pigment would produce a REDDISH-blue color. A lot of magenta pigment mixed with a little cyan White light is made up of RED, GREEN, and BLUE light.

This is a very important concept. White light may be made by mixing red light, green light and blue light. Knowing this, and remembering it, will help when you learn how we can produce colors other than red, green and blue by **mixtures** of red, green and blue light.

If you were to mix a lot of cyan with only a little magenta dye, you would produce a greenish-blue color. With a lot of magenta and only a little cyan, you would produce a ______ ish-blue color.

Before we begin talking about COLOR MIXTURES of red, green and blue, it is very important that we keep this in mind: We will be talking of mixing LIGHT not mixing paints as an artist does, or dyes as a photographer does (indirectly) when he exposes color film or paper, or inks or other pigments as a printer does.

You must understand the principles of mixing LIGHTS in order to understand the principles of mixing paints, dyes and inks. Mixing lights involves the ADDITION of lights, while mixing paints, dyes and inks involves the SUBTRACTION of light.

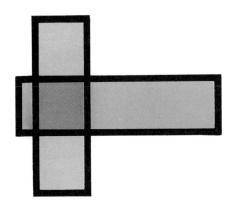

If you mixed only small amounts of magenta and cyan dyes, you would produce a PALE (or WEAK) blue color.

ТЕ яэмен

STATEMENT 25

IN THIS UNIT WE WILL BE TALKING ABOUT THE

ADDITION OF LIGHTS.

If you mixed only a little magenta and cyan dyes, you would produce a ______ blue color.

OS ABWENA

With strong magenta and cyan dyes, you see a STRONG (or DEEP or SATURATED) blue color.

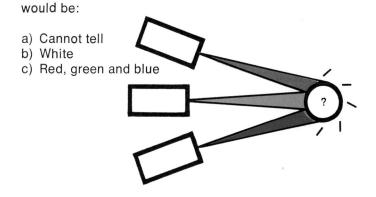

If I were to give you a red flashlight, a green flashlight and a blue flashlight and ask you to shine each on a white wall so that all three lights were equally superimposed or mixed, then the color(s) on the wall

Now consider this situation:

If your answer was: (b) White, excellent! When you add or mix red, green and blue light, in equal amounts, you should see white light.

If your answer was: (a) Cannot tell; there is a little uncertainty in your answer. If WHITE LIGHT can be separated into RED, GREEN and BLUE LIGHT, would you not expect the reverse to be true? Rethink frames number 21, 23 and 24. Use your light tunnel also.

If your answer was: (c) Red, Green and Blue, in a sense you are correct. You have, however, missed the point that when RED, GREEN and BLUE LIGHT are **mixed** (added or super-imposed) on the screen, then, what we can see is WHITE LIGHT. Rethink frames number 21, 23 and 24. Use your light tunnel also.

As before, the exact color of blue will depend on the amounts of the magenta and cyan dyes. Both dyes in the kit are strong, so you see a ______ blue.

The fact that red, green and blue light, when mixed in equal amounts, may produce white light can be stated mathematically:

RED LIGHT + GREEN LIGHT + BLUE LIGHT = WHITE LIGHT

Write a similar expression to show that white light can be separated into red light, green light and blue light.

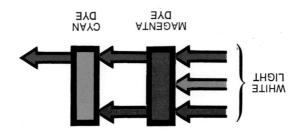

Only blue light is left from white light because the magenta dye absorbs GREEN light and the cyan dye absorbs RED light.

ANSWER 35

If you answered: $\begin{tabular}{ll} WHITE LIGHT = RED LIGHT + GREEN LIGHT + BLUE LIGHT (any order), you are absolutely correct. This is a mathematical expression for what you see when white light is separated into red light, green light and blue light. \\ \end{tabular}$

to see.
light. Thus only blue light is left for you
absorbs ————————————————————————————————————
or other pigments are mixed is that the magenta dye
The reason you see blue when magenta and cyan dyes

You may, at this point, be wondering why we have been stressing that:

- 1. Tungsten lamps and the sun are two very important sources of WHITE LIGHT,
- 2. WHITE LIGHT consists of RED, GREEN and BLUE LIGHT,
- 3. The ADDITION or MIXTURE of equal amounts of RED, GREEN and BLUE LIGHT can produce WHITE LIGHT.

The reason is this: THE ADDITION or MIXTURE of **unequal** amounts of RED, GREEN and BLUE LIGHT allows us to produce all the other colors we see. These include pinks, purples, browns, etc.

When overlapped or mixed, magenta and cyan pigments make the color BLUE.

АВ ЗА

summary 28

Equal mixtures of red, green and blue light produce neutrals such as white.

Unequal mixtures of red, green and blue light produce non-neutrals such as purple.

Next, place the magenta and cyan filters on top of each other. Where they overlap you see the color

Ccont'd) ANSWER (cont'd)

From Color Primer I you learn that hue describes the direction from neutral, saturation the distance from black from neutral and lightness the distance from black to white. (Frame 49)

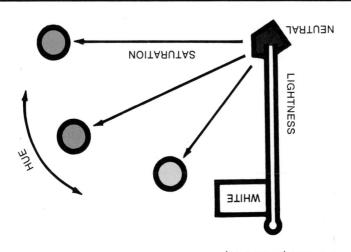

It is possible to produce a non-neutral color such as brown by _____ mixtures of red, green and blue

light.

QUESTION 29

It is possible to produce the color brown by UNEQUAL mixtures of red, green and blue light (any order).

Since we are able to produce the colors brown, purple, orange, or any others by the addition of unequal amounts of red, green and blue light, we have a system for producing colors. Technically, we call it the ADDITIVE SYSTEM of producing colors. We said earlier that color television is an example of an additive system.

These green colors differ in hue, or saturation, or lightness, or in any combination of these.

CC HEWENA (cont'd)

When we see colors having hues such as purple,
pink, brown and orange on color television, we
can say that the colors are produced by the
of producing colors.

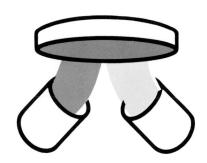

Different amounts of yellow and cyan pigments would produce many different kinds of GREEN colors.

ANSWER 30

The ADDITIVE SYSTEM allows us to produce all of the variety of colors we see by proper mixtures of red, green and blue light. The lights red, green and blue technically are called PRIMARY or PRIMARIES in the additive system because from these we can produce any color.

Thus, with different amounts of yellow and cyan dyes (or other yellow and cyan pigments), we can make many colors—strong or pale, bluish or yellowish—but all these colors would be different kinds of

SC RANSMA

A little cyan pigment with a lot of yellow pigment would produce a YELLOWISH-green hue.

In the additive color system, all the colors that we see can be formed by the addition in proper amounts, of red, green and blue light ______.

In the additive color system, all the colors that we see can be formed by addition in proper amounts of red, green and blue PRIMARIES.

Since this is an additive system, we can also refer to red, green and blue light technically as the ADDITIVE PRIMARIES. In the additive system of producing colors, proper mixtures of red, green and blue light allow us to produce any color we desire.

If we mix only a little yellow pigment with a lot of cyan pigment, we would make a bluish-green hue. If we mix only a little cyan pigment with a lot of yellow pigment, we would make a ______ish-green hue.

LE ABWENA

Mixed weak yellow and cyan dyes would make a WEAK or PALE green color.

Pale dyes or pigments, when combined, produce other pale colors.

ANSWER 32

Red, green and blue are called ADDITIVE PRIMARIES. They can be used to form purple or any other color.

For this unit, however, we will restrict ourselves to how we can produce the colors CYAN, MAGENTA and YELLOW. (In Color Primer II you will learn that these colors are the subtractive primaries.)

The exact **quantity** of the yellow and cyan pigments will determine the exact green they will make. The filter pigments in the kit are **strong**, so together they make a strong, saturated green. If the dyes were both weak, you would see a _____ green instead.

Let's go back to our flashlight experiment. We know that if we shine red, green and blue light on a white screen or wall so they are mixed or added in equal amounts, we could see _____ light.

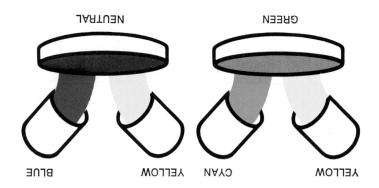

When we get a neutral color from yellow paint and another paint, we know that the other paint is BLUE.

ANSWER

ANSWER 33

If you answered WHITE light, you are correct. The mixing of red, green and blue light produces white light. (Rethink frames 21, 23 and 26 if you need to.)

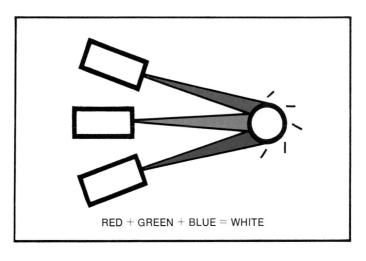

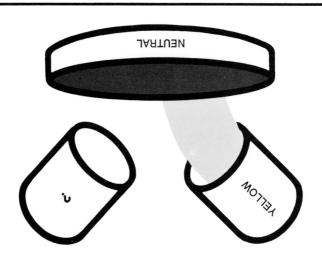

If, on the other hand, we mix yellow paint with another paint and get a nearly **neutral** color, we know that this second paint is _____.

Suppose, now, we mixed only the blue light and the green light.

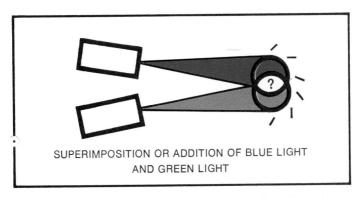

What hue would you expect in the area where the blue light and the green light **mix** or **add?** Answer______

(Remember you are mixing lights, not paints.)

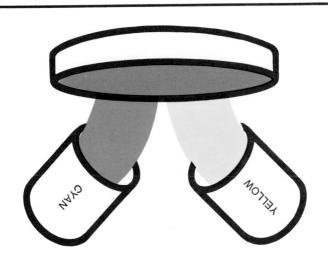

If we get a green hue by mixing yellow paint with another paint, the second paint must be CYAN.

When blue light and green light are mixed, the result is a CYAN hue. (Prove it to yourself by using your light tunnel and blue and green filters.)

If your answer was a Blue-Green and, if by Blue-Green, you mean the color will be a mixture or an addition of these two colors, your answer is acceptable, but please refer to this hue as CYAN.

We now know that when BLUE LIGHT and GREEN LIGHT are ADDED or MIXED, a new color, CYAN, is formed. We can write that:

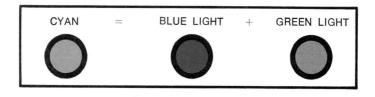

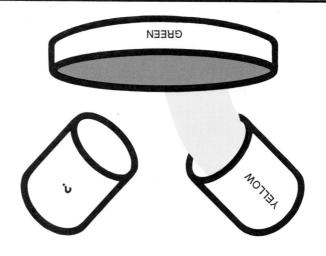

If we mix yellow paint with some other paint and obtain a green hue, we know that the other paint is _____.

ANSWER 28

When two pigments (or dyes or paints or inks) mix to make a green hue, the two pigments must be YELLOW and CYAN (either order).

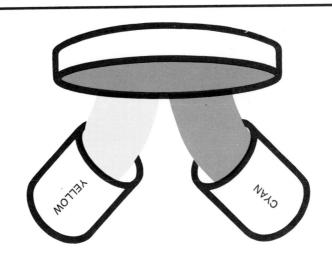

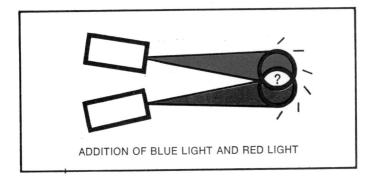

If we now mix blue light and red light, we will form a new color. The hue of the color is _____.

MAGENTA is formed when blue light and red light are mixed. (Prove it by using your light tunnel and blue and red filters.)

For someone not familiar with the hue of the color MAGENTA, you could describe it as a Bluish-Red, or a hue intermediate between blue and red.

We have learned that the color MAGENTA can be produced by the addition or mixture of blue light and red light. We can write:

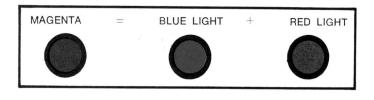

When two pigments mix to make a green hue, the pigments are _____and

(conf'd) ANSWER 27

Note that Blue and Yellow Pigments produce a green. neutral. Cyan and yellow pigments produce a green.

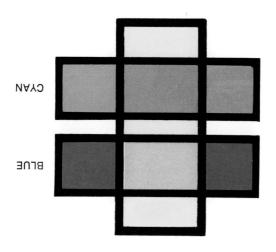

We can write that CYAN = _____

QUESTION 36

CYAN = BLUE LIGHT + GREEN LIGHT

The addition or mixture of blue light and green light forms a new hue we call CYAN.

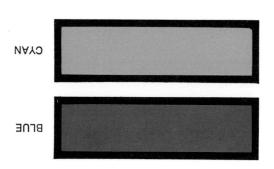

(The error implied in question 27 comes from a confusion between blue and cyan. They are really different, as you can see by comparing the **blue** part of the test object with the **cyan** filter.)

(cont'd) ANSWER 2/

TS ABWER

BLACK (or DARK NEUTRAL). BLACK (or DARK NEUTRAL).

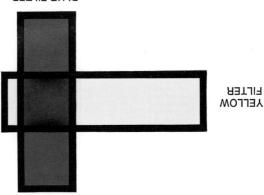

BLUE FILTER

MAGENTA =	
+	

$MAGENTA = BLUE\ LIGHT + RED\ LIGHT$

The addition or mixture of blue light and red light forms a new hue that we call MAGENTA.

You may have been taught incorrectly that yellow and blue make a green hue. But recall that when you placed the yellow-dyed filter over the blue test object, you saw a very dark, nearly neutral appearance. Thus, yellow pigment on blue pigment would not make a green hue, but instead

We have mixed blue light and red light and produced MAGENTA; blue light and green light, and produced CYAN. If we mixed red light and green light, we could get a new hue that we call _____.

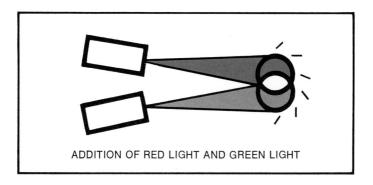

The same reasoning applies to yellow and cyan paints or inks as used in printing.

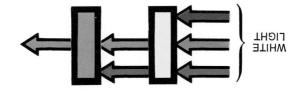

Since the yellow dye absorbs BLUE light, and the cyan dye absorbs RED light, only the **green** light is left to see.

ANSWER 26

The hue YELLOW may be produced by mixing RED and

GREEN light.

(Prove it to yourself by using your light tunnel with red and green filters.)

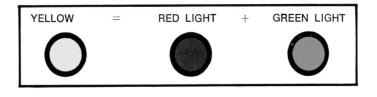

It is reasonable for overlapped yellow and cyan filters to produce a **green** hue; the yellow dye absorbs _____light; the cyan dye absorbs _____light is left to only the green portion of the white light is left to enter your eyes.

Yellow and cyan filters on top of each other produce a GREEN hue.

The same result appears when yellow and cyan pigments (paints) are mixed, because the small particles of pigments act like filters.

The two additive primaries used to produce MAGENTA

____ and _

QUESTION 39

ANSWER 39

BLUE and RED are the two ADDITIVE PRIMARIES used to produce MAGENTA.

Because the yellow, magenta and cyan filter dyes each absorb just one of the three main colors of white light, you can make other hues (kinds of colors) by placing the filters together. Put the yellow and cyan filters on top of each other, and look through them at a white light. You see a hue of

QUESTION 40

MAGENTA is formed by adding the two additive primaries BLUE and RED.

When the two additive primaries red and green are added together, a third color is formed that has a _____ hue.

MEAK	LELLOW	əlffil	Blue
эиоятѕ	CXAN	Мисћ	Ред
эиоятѕ	АТИЭБАМ	Мисһ	Green
MEAK	CAPN	əlffil	Red
MEAK	АТИЭБАМ	əlĦiJ	Green
STRONG	ΛΕΓΓΟΜ	Мисћ	Blue
STRENGTH OF FILTER	COLOR NAME OF FILTER	AMOUNT OF LIGHT TO BE ABSORBED	COLOR OF COLOR OF

PNSWER 24

YELLOW may be formed when the two additive primaries red and green light are mixed.

Blue	Little		
Ред	Мисh		
Green	Мисһ		
COLOR OF ABSORBED	AMOUNT OF LIGHT TO BE DBSORBED	COLOR NAME OF FILTER	STRENGTH ОF FILTER (STRONG ОR WEAK)

Ccont'd) QUESTION

		əlffil	рәЯ
		əlttid	Green
		Мисћ	Blue
STRENGTH OF FILTER (STRONG OR WEAK)	COLOR NAME OF FILTER	AMOUNT OF LIGHT TO BE ABSORBED	COLOR OF

When the two additive primaries blue and green are added or mixed together, a new color is formed that

has a _____ hue.

QUESTION 41

When blue and green are added together CYAN is formed.

the questions which follow:

In color photography, a photographer often needs to change the amount of red, green or blue light falling on the color film in order to get a pleasing picture. To do this, he uses a cyan, or yellow or magenta filter, absorbed. He uses a strong or weak filter depending on the color of light that needs to be absorbed. He uses a strong or weak filter depending on the amount of that color that he needs to absorb. From what you have learned in this color primer, complete

DOUESTION 24

QUESTION 42

We have observed that when **two** of the components of WHITE LIGHT are added or mixed together, we can form the colors that have CYAN, MAGENTA or YELLOW hues.

List the two primary colors that are added to form cyan, magenta and yellow.

CYAN	=+
MAGENTA	=+
YELLOW	=+

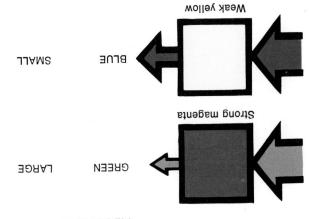

COLOR OF AMOUNT OF LIGHT ABSORPTION CHIGHT

PIGMENT

ANSWER 23b

answer 42

 $\mathsf{CYAN} = \mathsf{BLUE} + \mathsf{GREEN}$

MAGENTA = BLUE + RED

 ${\sf YELLOW} = {\sf RED} + {\sf GREEN}$

If you had them all correct, excellent! If not, review them and learn them. Remember, we are mixing **lights** and not paints or inks.

-	Меак, уеШом
	Strong, magenta

 PBSOBBED

 FIGHT
 ABSORPTION

 COLOR OF
 AMOUNT OF

PIGMENT ABSORBI

(cont'd) QUESTION

ANSWER

PIGMENT

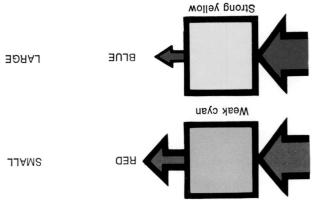

QUESTION 4

RED, GREEN and BLUE LIGHT are primaries of white light. We mix them in different combinations and amounts to produce other colors. We can refer to the red, green and blue lights as _____ primaries.

-		
		Strong, yellow
		Меак, суап
AMOUNT OF ABSORPTION (LARGE OR SMALL)	COLOR OF ABSORBED	ысмеит
S NOITS SUD	(cont'd)	

RED, GREEN and BLUE are the ADDITIVE primaries.

answer 43

You have noted that the colors CYAN, MAGENTA and YELLOW can be formed by the addition of two of the _____ of white light.

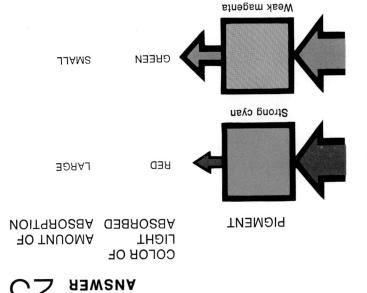

The colors CYAN, MAGENTA and YELLOW can be formed by the addition of two of the PRIMARIES of white light.

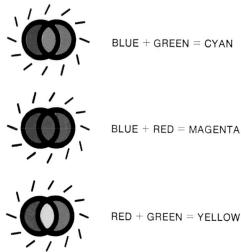

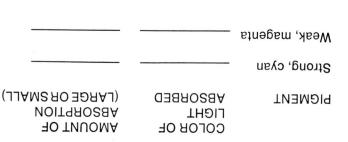

You have now learned that there are three major colors of pigments—yellow, magenta and cyan—each of which will absorb mainly one of the three important colors in white light—red, green and blue. You have also learned that the amount of the pigment affects how much of that specific color it will absorb. With this knowledge, complete the sequence of questions which follow:

QUESTION 23

If we were to add all three of the additive primaries in

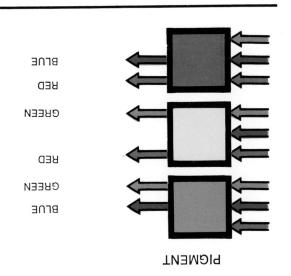

The colors of light that are not absorbed by the three

ANSWER

bigments are:

equal amounts, we would produce _____ colors.

NEUTRAL colors (white, gray, black) are produced when equal amounts of red, green and blue light are mixed.

Although colors such as white, gray and black are all neutrals, they are different because they vary in **lightness.** White is lighter than gray and gray is lighter than black.

Magenta	and
Yellow	and
Суап	gue ———

COLORS OF LIGHT NOT ABSORBED

PIGMENT

Each of the three pigments has very little absorption for two colors of white light. Fill in the table below:

SOUESTION 22

LS RANSWA

The main absorptions of the dyes, like other pigments,

	DЭЫ	СХУИ	
	BLUE	AEFFOM	
, O	СВЕЕИ	ATN∃ÐAM	
T ABSORBED	ГІСН		DAE

Colors such as white, gray and black are neutral colors,

that have different _____

QUESTION 46

QUESTION 2

COLOR ABSORBED

From these visual tests, you have seen that each of the three dyes (cyan, magenta and yellow) absorbs mainly one of the three major colors in white light. Complete

White, black and gray are neutral colors of different LIGHTNESS. They are all made up of equal amounts of red, green and blue light of different levels of intensity.

ANSWER 46

Cyan

Yellow

DAE

the table below:

Magenta

0	+	0	+	0	=	0
	+		+		=	0
	+	1	+		=	

The additive mixture of equal amounts of red, green and blue light that make white are of higher ______ than those which make gray.

A very pale cyan watercolor paint absorbs only a SMALL amount of red light.

Saswer 20

The additive mixture of equal amounts of red, green and blue light that make up white are of greater INTENSITY than those which make up gray.

A very pale cyan watercolor paint absorbs only a amount of _____ light.

In an additive process, neutral colors of different LIGHTNESS or BRIGHTNESS are made by equal amounts of red, green and blue light at different intensities.

The words LIGHTNESS and BRIGHTNESS are sometimes used interchangeably; brightness more often than lightness. Each, however, has a somewhat different meaning as pictured on the next page.

When a photographer wants to remove almost all the red light from white light, he uses a STRONG (or DEEP or SATURATED) CYAN filter.

61 ANSWA

Your perception of the amount of light entering your eye directly from a source of light is called BRIGHTNESS, while the amount of light entering the eye from some reflecting surface is called LIGHTNESS.

When we are looking at red, green and blue light superimposed and reflected from a wall or screen, we talk about LIGHTNESS. When we are looking at red, green and blue light phosphors from a TV screen, then we talk about BRIGHTNESS.

(In the Munsell system of color notation, the word VALUE is used to refer to both brightness and lightness.)

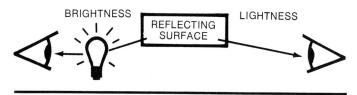

Lightness (or Brightness) then is a third word that we can use to distinguish how colors differ.

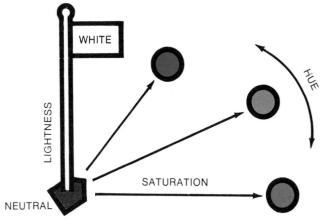

The other two words you learned earlier, were and ______.

Only a little red light would be absorbed by a SMALL amount of CYAN pigment.

Hue and saturation can be thought of as vectors; hue indicates the direction of a color relative to neutral, while saturation refers to the position or magnitude of the particular hue.

You can think of lightness as also describing **position** if you picture the baseball field analogy as being three dimensional. The third dimension would be lightness. Think of this in terms of a flagpole at home base. If you raise a flag up the pole, it changes lightness from black through gray to white at the top of the pole. (See the sketch on the previous page.)

	—— bigment.	amount of
е ру а	light would be absorb	Only a little red

question 50

Colors, then, can be described in terms of three dimensions or attributes:

- 1. _____
- 2. _____
- 3. _____

Almost all the red light would be absorbed by a STRONG (or DEEP or SATURATED) cyan pigment.

T ABWENA

1. HUE 2. SATURATION

3. LIGHTNESS

These terms give us three ways in which we can talk about color.*

Example 1: The sunflowers were a deep (saturation) gold (hue) and had a lightness (value) all their own.

Example 2: In our early schooling, many of us were taught that black is not a color, that it is the absence of color. Such a statement is misleading. Black is a color without hue, of zero saturation, and of very low lightness.

(*In the Munsell system of color notation, the equivalent terms are hue, chroma and value.) When we say an apple is red, we refer to its hue; the amount of redness we call SATURATION and LIGHTNESS refers to our perception of the amount of light reflected by the apple.

Let us return now to additive mixtures of light.

If you have **unequal** mixtures of red, green and blue light you will have a color other than ______.

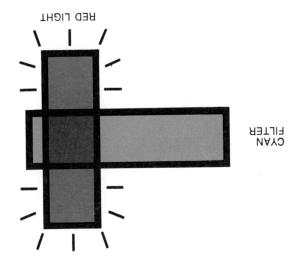

The cyan filter strongly absorbs RED light.

OL ABWENA

Unequal mixtures of red, green and blue light produce colors other than NEUTRAL. White or gray are also acceptable answers, since they both are neutral colors. The best answer however is NEUTRAL. Unequal amounts of all **three** additive primaries would produce non-neutral colors such as pinks, browns, purples, etc. Equal amounts of all **three** additive primaries produce NEUTRAL colors. Equal amounts of **two** additive primaries produce CYAN, MAGENTA or YELLOW.

With the cyan filter, the third color of the test object looks very dark and almost neutral. From this observation, you see that the cyan filter has a strong absorption for ______ light.

Black, gray and white are all _____ colors which vary in lightness only.

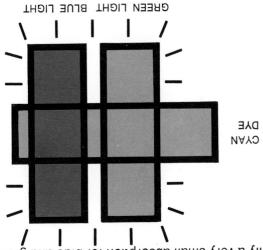

The cyan dye hardly changes the BLUE and GREEN colors of the test object. Therefore, a cyan pigment has only a very small absorption for blue and green light.

CL ANSWA

Black gray and white are all NEUTRAL colors. They vary only in their **lightness**. This can be illustrated on the scale of neutrals to the right.

A NEUTRAL GRAY SCALE OR LIGHTNESS SCALE

Now test the third dyed filter—the cyan filter—with the red, green and blue test object. The two colors that are not much changed are _____.

ANSWER 14

We control the amount of **blue** light with different amounts of YELLOW pigment, and the amount of **green** light with different amounts of MAGENTA pigment. The yellow pigment leaves the red and green light almost unchanged; the magenta pigment leaves the

red and blue light almost unchanged.

White, gray and black are neutral colors varying only in _____ and are produced by mixing equal

amounts of red, green and blue light.

answer 53

Neutral colors such as white, gray and black vary only in LIGHTNESS and are produced by mixing equal amounts of red, green and blue light.

* ,	white light.
atly affecting the other two major colors of	without grea
ounts of pigment, in each case,	different am
can control the amount of green light with	and that we
fferent amounts of pigment,	
ow that we can control the amount of blue	You now kn

DL MOITS TA

QUESTION 54

Neutrals such as white, gray and black look different because they vary in LIGHTNESS. Arrange the neutral colors in order of **de**creasing lightness.

- 1._____
- 2.____
- 3._____

A pale magenta paint, when placed on white paper, absorbs a SMALL amount of GREEN light.

EL Hawsha

ANSWER 54

- 1. WHITE
- 2. GRAY
- 3. BLACK

White is the **lightest** neutral. If the white light were coming directly from a source of white light, such as a tungsten bulb, we would refer to white as being the **brightest** neutral.

	light.
o fanoms ——	of white paper, the paint absorbs a —
aint on a piece	Myeu a painter puts a pale magenta p

We have learned that:

1. The addition of two of the red, green and blue primaries of white light will produce colors having cyan, magenta and yellow hues.

2. The addition of equal amounts of all three primaries of white light will produce neutrals.

To remove most of the green light, a photographer uses a STRONG (or DEEP or SATURATED) MAGENTA filter.

3. Colors such as black, gray and white are all neutrals varying only in lightness.

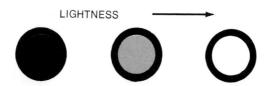

4. Proper additions of unequal amounts of all three primaries will produce all of the non-neutral colors such as pinks, purples, browns, etc.

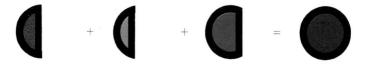

If a photographer wants to remove **most** of the **green** light from white light, he would use a <u>lilter.</u>

The diagram below illustrates an **equal** mixture of the three additive primaries. Please study it.

ADDITIVE MIXTURES
OF EQUAL AMOUNTS OF RED.
GREEN AND BLUE LIGHT

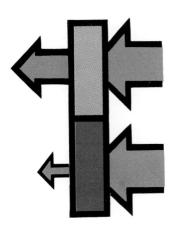

A very deep magenta dye (filter) would absorb much GREEN light; a pale magenta dye would absorb only a little GREEN light.

ANSWER |

Before answering the questions which follow return to the additive mixtures on the previous page and make these observations:

- a) The large circles represent the three additive primaries, red, green and blue **light.**
- b) The primaries have been mixed in equal amounts.
- c) Where **two** of the primaries overlap, cyan, magenta, and yellow are formed.
- d) Where all **three** of the primaries overlap or mix, a neutral, in this case, white, is formed.

Are you ready for some questions? Proceed!

.hdgil	only a little.	spsorb	ye would	р
a weak (pale) magenta	;tdgil	jo	reat deal	6
nta dye would absorb a	ated) mager	b (satur	и леку дее	4

The diagram below represents addition or mixtures of the red, green and blue light primaries in equal amounts. What colors would you expect to find in the areas marked 1, 2, 3 and 4?

AREA	COLOR
1.	
2.	
3.	
4.	

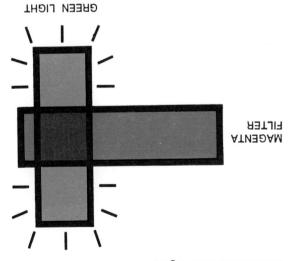

Like other magenta pigments, a magenta filter strongly absorbs GREEN light.

Or Hawsha

The correct answers are: 1. Magenta, 2. Yellow, 3. Cyan, 4. White.

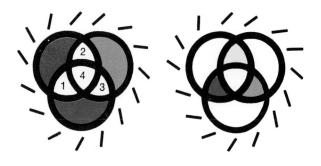

With the magenta filter, on the other hand, the green color of the test object looks very dark and almost neutral. From this observation, you know that the magenta filter strongly absorbs ____ light.

(either order) light.

If the mixtures of red, green and blue light were of a low lightness, the number 4 area (white) would look

A magenta pigment absorbs almost no RED or BLUE

ANSWER

ANSWER 58

Number 4 area (white) would look GRAY or grayish if the mixture of red, green and blue light were of low lightness. This is the way gray suits are reproduced on color television. If you answered black, this would also be acceptable, since you were probably thinking of a lower lightness than that which produced the gray. White, gray and black are all neutral colors varying only in lightness.

From this observation, you know that a magenta pigment has very little absorption for or ______ light.

Now look at this representation of equal mixture of red, green and blue light and name the colors in the areas marked A, B, C and D.

AREA	COLOR
Α.	
В.	
C.	
D.	

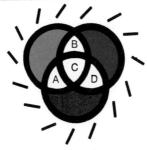

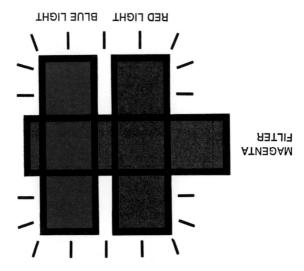

The magenta filter has almost no effect on the RED and BLUE (either order) colors of the test object.

The correct answers are: A. Yellow, B. Cyan, C. White (Gray also acceptable), D. Magenta.

Now, place the magenta filter over the same red, green and blue test object. See that the magenta filter has little effect on two of the colors of the test object. These two colors are ____and___.

Now see if you can work backward and list the mixtures of the primaries that produced the colors cyan, magenta and yellow. The primaries in areas 1, 2 and 3 are:

AREA	COLOR
1.	
2.	
3.	

A painter uses yellow paint to reduce the amount of BLUE light reflected from the white canvas (or white paper). The amounts of GREEN and RED light are hardly changed.

ANSWER 60

The correct answers are: 1. Blue, 2. Red, 3. Green.

When an artist puts a yellow paint on a white canvas, he is using the pigment to reduce the amount of light reflected from the canvas. There is hardly any change in the

How did you do? Well, I hope. Now try this last panel. Identify the colors you would expect to see in areas A, B, C and D.

AREA	COLOR
Α.	
B.	
C.	
D.	

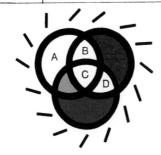

We use a yellow pigment to control the amount of BLUE light by absorption, but the yellow pigment has almost no effect on the RED or GREEN light.

О язмем

Check your answers against these: A. Green, B. Yellow, C. White, D. Magenta.

	.light.	٥١
	ost no effect on the amount of	with alm
,†dgil	by absorption, the amount of	control,
or weak, to	use a yellow pigment, either strong	

We see, then, that the addition of **two** primaries produces cyan, magenta or yellow and the addition of **three** primaries, in equal amounts, produces a neutral. The neutral is white when the lightness is high, gray when the lightness is medium or low, and black when the lightness is very low.

Remember, now, we have been talking only about mixtures of **lights**, not paints.

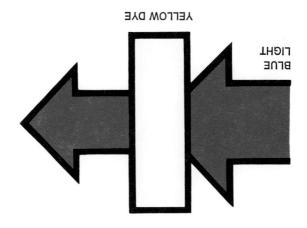

To absorb only a little blue light, we would use a WEAK (or PALE) YELLOW dye.

SUMMARY

You have successfully reached the end of this unit. Well done! You have learned:

- 1. To identify by their correct technical names the colors RED, GREEN, BLUE, CYAN, MAGENTA, YELLOW, BLACK, WHITE and GRAY.
- 2. That BLACK, GRAY and WHITE are NEUTRAL COLORS.
- 3. That the three attributes or characteristics of color are HUE, SATURATION and LIGHTNESS or brightness.
- 4. That TUNGSTEN light and SUN light are two important sources of WHITE LIGHT.

little blue light, we would use a On the other hand, if we want to remove (absorb) only a

(cont'd) SUMMARY

- 5. That white can be separated into RED, GREEN and BLUE light and that an equal mixture of red, green and blue light produces white light.
- That red, green and blue light are ADDITIVE PRIMARIES.

7. That CYAN = BLUE + GREEN

MAGENTA = BLUE + RED

YELLOW = RED + GREEN

That WHITE = RED + GREEN + BLUE= RED + GREEN + BLUE

(less lightness than white)

 $\mathsf{BLACK} = \mathsf{RED} + \mathsf{GREEN} + \mathsf{BLUE}$

(less lightness than gray)

That we have been talking about the ADDITIVE PROCESS and we have been mixing **lights**, not paints.

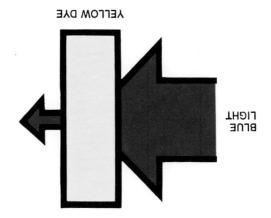

To remove almost all the blue light we use a STRONG (or DEEP or SATURATED) yellow dye.

(cont'd) SUMMARY

- 8. That **equal** amounts of three primaries produce neutrals and **unequal** amounts of three primaries produce all other non-neutral colors such as brown, purple, pink, etc. Equal amounts of two primaries produce cyan, magenta or yellow.
- 9. That color television is an example of a color system which operates on the principles of the **additive** system of producing colors.
- That lightness refers to our perception of the amount of light reflected from a surface, while brightness refers to our perception of the amount of light emitted directly from a source of light.

Are you ready for your final set of questions? Proceed!

Thus, in every subtractive color process, a yellow pigment is used to remove more or less blue light from the original white light. If we want to remove all the blue light we use a ________yellow dye.

A strong yellow filter would absorb almost all the blue light.

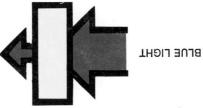

A weak yellow filter would absorb only a little BLUE light.

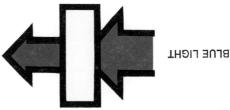

3a.The three	words	used t	o describe	e the	different
attributes	of colo	r are_		.,	
and					

2. Which of the nine colors above are neutrals?

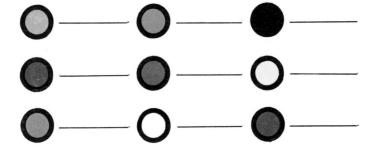

1. Name the following colors:

1.

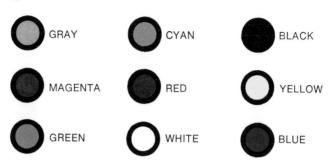

- 2. WHITE, GRAY and BLACK are neutrals.
- 3a. HUE, SATURATION and LIGHTNESS describe the different attributes of color.

A very deep (saturated) yellow filter would absorb almost all the blue light. A very pale (weak) yellow filter would absorb only a little ______light.

QUESTION 63

3.	b. Hue tells the of a color relative to a neutral (home base).
	c. Saturation tells the of a color relative to a neutral (home base).
	d. Lightness or brightness tells the of a
	color on a scale of lightness or brightness
	(flagpole analogy).
4.	a. The perceived intensity of light reflected from an object is called
	b. The perceived intensity of light directly from a source of light such as a TV screen or a lamp is called
	c. A reflection gray scale consists of a scale of
	o. A following gray scale collisists of a scale of

neutral areas that vary in _____

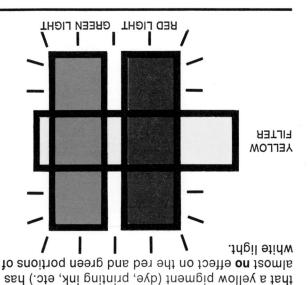

The RED and GREEN colors of the test object are almost unchanged by the yellow filter. Thus you see

- 3. b. Hue tells the direction of a color relative to a neutral.
 - c. Saturation tells the position of a color relative to a neutral.
 - d. Lightness or brightness tells the position of a color on a scale of lightness or brightness.
- 4. a. Lightness is perceived intensity of light reflected from objects.
 - b. Brightness is the perceived intensity of light directly from a source of light.
 - c. Reflection gray scales have a scale of neutral areas that vary in lightness.

•	— рив ——	gre	colors
almost unchanged. These	et object are	of the tea	colors
note that the other two	ellow filter, ı	ле ѕчше у	11 HIIW

5. a. An important source of white light indoors is

b. An important source of white light outdoors is the _____.

6. When red, green and blue light of equal amounts are mixed, the result is ______light.

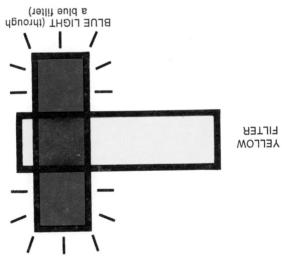

The yellow dye strongly absorbs the BLUE light that was present in the white light. All yellow dyes and other pigments absorb blue light.

ANSWER

- 5. a. An important source of white light indoors is tungsten.
 - b. An important source of white light outdoors is the sun.
- 6. White light is produced by equal mixtures of red, green and blue light.

7.	In the additive system of producing colors, the three additive primaries are,,
8.	When mixed in equal amounts:
	Red light $+$ green light $=$ $-$
	Green light $+$ blue light $=$ $-$

- 9. The colors that you see on color television are produced by the mixtures of red, green and blue lights. (The lights originate from the red, green and blue phosphors in the screen.) What mixtures of red, green and blue lights (phosphors) are required to produce the colors below:
 - a) a yellow banana d) gray suit b) black automobile e) cyan hat c) magenta dress f) white shirt

Blue light + red light = ---

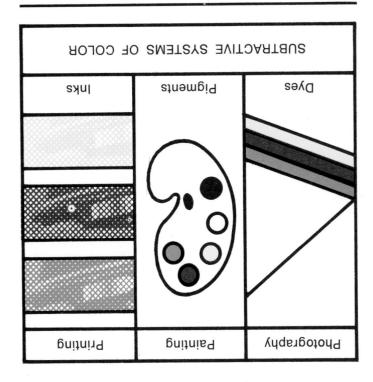

- 7. In the additive system, the three primaries are RED, GREEN and BLUE.
- 8. Red + Green = YELLOW Green + Blue = CYAN Blue + Red = MAGENTA
- 9. a) Yellow = RED + GREEN
 - b) Black = RED + GREEN + BLUE (low lightness)
 - c) Magenta = RED + BLUE
 - d) Gray = RED + GREEN + BLUE (medium lightness)
 - e) Cyan = GREEN + BLUE
 - f) White = RED + GREEN + BLUE (high lightness)

- That almost any color can be made by mixing different amounts of just three basic pigments.
- 9. That placing all three basic pigments together may make neutral colors (grays);
 - pigments makes different hues;
 - 8. That changing the relative amounts of the two nigments makes different buses.
 - That using small amounts of the basic pigments makes weak (pale, unsaturated) colors;

QUESTION 66

- 10. An important color producing device based on an additive system is _
- 11. Write a general statement to describe how colors other than neutrals are formed.
- 12. Explain why it is correct to refer to black and white as colors.

- produces strong (saturated) colors;
- That using large amounts of the basic pigments
- basic pigments together in different pairs; That all different hues can be made by placing the
 - will absorb; pigments determines how much of the light they
 - That the amount (strength) of the three basic
 - pasic pigments; 3. The colors of light that are not absorbed by these
 - pasic pigments;
- The color of light that is absorbed by each of these
 - paints, filters); 1. The names of the three basic pigments (dyes,

ten things:

COFOR PRIMER II is designed to help you learn these

THINGS YOU WILL LEARN

- 10. Television is a device that produces colors by additive mixtures of red, green and blue light.
- 11. Colors other than neutrals are produced by unequal mixtures of red, green and blue light.
- 12. Color has three attributes: hue, saturation and lightness. Black and white are neutral colors of very low and high lightness and no hue or saturation.

Black is not the absence of color, but rather the absence of hue and saturation.

You have finished Color Primer I. To Start Color Primer II, turn two pages, rotate the book and start with the Introduction to Color Primer II.

Viewing the test object through yellow filter.

Additions or mixtures
red with green 38, 40, 65
green with blue 34, 36, 41, 65
blue with red 35, 37, 39, 65
red with green with blue 19, 21, 24, 27, 33, 57, 59, 64
Additive
primaries 22, 23, 32, 39, 43, 51, 65
systems 29, 30, 65
Attributes of color
hue 20, 50, 63, 66
lightness or brightness 50, 62, 66
saturation 50, 62, 66

Baseball analogy
hue 6, 8, 9
lightness 49
saturation 7, 8, 9
Black 15, 50, 66
Brightness 48, 63
Brightness/lightness 48, 49, 63

you understand it, write in the answer and then go to the next item.

to the next item.

1. Read each item carefully, and when you feel that you understand it, write in the answer.

convenience. This program was especially designed for you. Follow these instructions:

Colors

cyan, magenta, yellow 13, 14, 16, 42, 60, 62 red, green, blue 14, 16, 20, 22, 26, 33, 62 white, gray, black 2, 14, 16, 46, 54, 62 Color mixtures 25 Cyan 11, 13, 34, 41, 65

Direction (hue) 6, 9, 63

Equal amounts 26, 27, 56, 64

Flagpole analogy (lightness) 49 Flashlight experiments 26, 33, 34, 35, 38

Gray 15, 58, 65 Gray scale 52, 63

Hue 3, 6, 8, 10, 62, 63

You are about to learn more basic concepts of color by yourself, at your own speed, and at your own

The other set of three dyed filters represents the typical dyes (pigments) used in subtractive color processes. They are **yellow**, **magenta** and **cyan**. When you hold each of these in front of the red, green and blue filters, you can see how the dyes absorb the red, green and blue lights present in white light.

With this Color Primer, you are supplied with two sets of three colored (dyed) filters. One set is colored red, green and blue. Use this set as a test object. When you hold this set of dye filters in front of a white light, you see separately the red, green and blue lights which are present in the white light. The red filter lets through only the red light present in the white light; the green filter, mainly the green light; and the blue filter, mainly the blue green light;

Indigo 20 Intensity 47, 63

Lightness 45, 51, 53, 58, 62, 63, 65, 66 Lightness/brightness 48, 49, 54, 63

Magenta 12, 13, 35, 37, 39, 65 Mixtures or additions (see additions) Munsell 48, 50

Neutrals 2, 4, 6, 15, 19, 45, 51, 62, 63, 66 Non-neutrals 19, 28, 29

Orange 20

Phosphors 19, 48, 65
Position (lightness) 49, 63
Position (saturation) 9, 63
Primary (primaries) 22, 30, 43, 44, 65

Thus, in the subtractive process of color reproduction, the absorption characteristics of the pigments (dyes, etc.), are important.

In the additive method, we begin with a dark screen needed amounts of the red, green and blue lights to make the required color. In the **subtractive** method, we begin with a **white** screen, like a slide or movie projection screen, or with a white piece of artist's or printer's paper. When we place a slide in the projector, or put paint or ink on the paper, we are inserting or put paint or ink on the paper, we are inserting smounts of the primary lights, leaving the rest of the light for us to see.

colors is named the **subtractive** method of color reproduction.

Prism 20

Saturation 7, 8, 10, 51, 62, 63 Subtraction 25 Summary pages 28, 55, 61, 62 Summary questions 14, 16, 42, 44, 62-66

Sun 18, 20, 64 Spectrum 20

Television 19, 30, 48, 66 Three primaries 45, 55, 56, 61, 65 Two primaries 41, 44, 55, 65 Tungsten light 19, 20, 64

Unequal amounts 28, 51, 55, 66

Value 48 Violet 20

COLOR PRIMER II is about a different way of making colors. Instead of using colored lights, this second way uses colored substances, like paints or dyes or inks or crayons. These colored substances have the general name of pigments. Pigments work to produce oclore by absorbing (subtracting) one or more of the colors by absorbing (subtracting) one or more of the three primary lights. Thus this second way of making

real color.

From COLOR PRIMER I, you learned that any hue can be made by mixing different amounts of just three colored lights—red, green and blue. You learned that red, green and blue are the primary colored lights. You also learned that the neutral colors—whites, grays and blacks—can be made from the three primary lights by mixing them in equal amounts. You learned that we call this the additive method of making different colors, and that this is the way a color television receiver can reproduce practically every television receiver can reproduce practically every

INTRODUCTION

INDEX

White 4, 15, 23, 26, 65 White light 17, 19, 21, 24, 26, 33, 42, 64

Yellow 11, 13, 38, 40, 65

Perry Center, N.Y.

COLOR PRIMER I: ADDITIVE

PRIMARIES: RED, GREEN and BLUE LIGHT

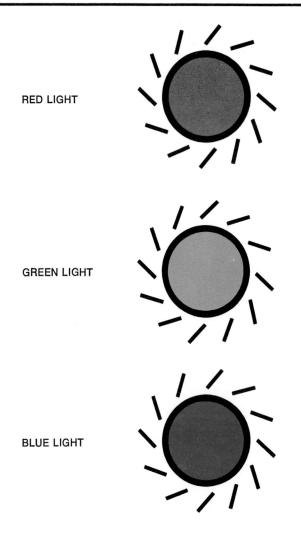

Example of Use

Television—Red, Green and Blue phosphors (Lights) are used.

COLOR PRIMER II: SUBTRACTIVE
PRIMARIES: CYAN, MAGENTA and YELLOW PIGMENTS

CYAN PIGMENTS STOP RED LIGHT

MAGENTA PIGMENTS STOP GREEN LIGHT

YELLOW PIGMENTS STOP BLUE LIGHT

Examples of Use

Photography—Dyes Artist—Paints Printer—Inks

COLOR PRIMER I: ADDITIVE TO PRODUCE

TO PRODUCE CYAN mix green light with blue light.

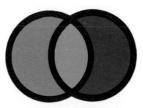

MAGENTA mix red light with blue light.

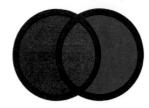

YELLOW mix red light with green light.

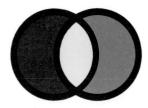

NEUTRAL mix equal amounts of red, green and blue light.

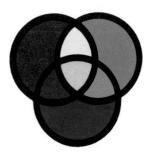

Changing the intensities of the red, green and blue lights changes the hue, saturation and lightness of the color.

COLOR PRIMER II: SUBTRACTIVE TO PRODUCE

TO PRODUCE RED

mix magenta pigment with yellow pigment.

GREEN

mix cyan pigment with yellow pigment.

BLUE

mix cyan pigment with magenta pigment.

NEUTRAL

mix equal amounts of cyan, magenta and yellow pigments.

Changing the amounts of the cyan, magenta and yellow pigments changes the hue, saturation and lightness of the color.